D0463246

GRADATED TONES

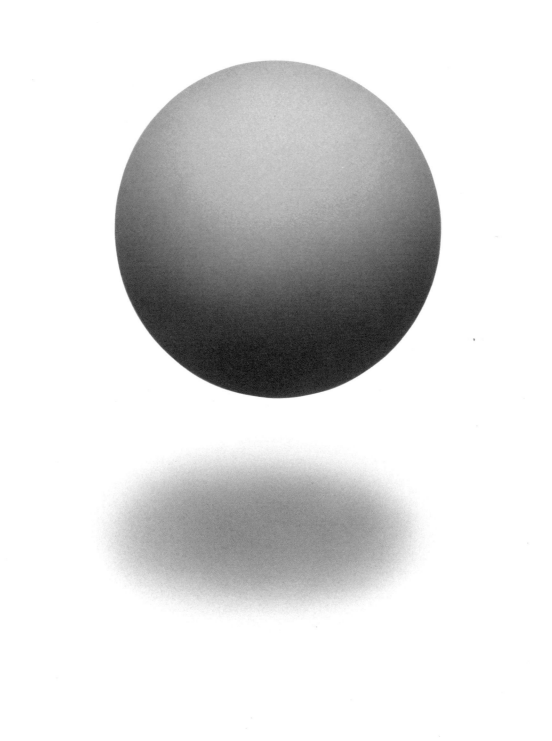

AIRBRUSH
ARTIST'S
LIBRARY

GRADATED
TONES

JUDY MARTIN

NORTH LIGHT BOOKS

Cincinnati, Ohio

This book was designed and produced by
QUARTO PUBLISHING PLC
The Old Brewery, 6 Blundell Street
London N7 9BH

SERIES EDITOR JUDY MARTIN
PROJECT EDITOR MARIA PAL
EDITOR RICKI OSTROV
DESIGN GRAHAM DAVIS
PICTURE RESEARCHER JACK BUCHAN
ART DIRECTOR MOIRA CLINCH
EDITORIAL DIRECTOR CAROLYN KING

Typeset by Text Filmsetters, London
Manufactured in Hong Kong by Regent
Publishing Services Ltd
Printed by Leefung-Asco Printers Ltd, Hong Kong

A QUARTO BOOK

Copyright © 1988 Quarto Publishing plc

First Published in the USA by
North Light Books, an imprint of
F & W Publications, Inc
1507 Dana Avenue
Cincinnati, Ohio 45207

All rights reserved.
No part of this book may be reproduced in any
form or by any means without permission from
the Publisher.

ISBN 0-89134-260-5

CONTENTS

TONE AND COLOR IN AIRBRUSH ART

Effects of graded tone and color are the elements of airbrushing which contribute the highly finished, illusionistic qualities so impressive in professional examples of the art. The airbrush is a unique tool for the artist, the only one that does not touch the picture surface in order to lay the paint medium; the fineness of the airbrush spray provides a coherent surface texture undisturbed by direct manipulation of the medium. The uniform surface effects, through broad background areas to the most delicate details, create the photographic intensity of certain types of airbrush painting; the success of more stylized illustrations and general graphic work often also depends upon the artist's ability to work up areas of unblemished flat color and subtle gradations through a range of tones and hues.

It is important to distinguish the functional roles of tone and color in an image. In simple terms, tone is a pattern of light and shade falling upon a surface or object, whereas color is an inherent property of the material of which a surface or object is made. Tone describes three-dimensional forms, their location and spatial relationships, and relative distances within the picture plane. Color has more to do

with identification in real terms, and can also be used to create atmosphere and subjective values in a composition.

Basic definitions of this kind set aside the inter-relationships of tone and color which must be confronted in making a graphic image. In a highly realistic airbrush rendering, both elements contribute equally to the visual accuracy of the image: an apple may be represented by imitating the natural reds and greens in its coloring, for example, but it is the shadows and highlights – the tonal values – which emphasize the roundness of the shape. Either element can be used to create a recognizable image; together they construct an informative and unambiguous representation.

Even the most complex illustration is only a combination of shape, color and tone: the skill of the artist lies in both identifying the individual components of an image and understanding how to produce these technically. This book examines these aspects of the airbrush artist's work, starting with the basic technique of producing a perfect flat tone or color, moving to subtle effects of gradation and the way these are applied to the depiction of specific objects, and relating the airbrushing exercises to highly finished professional illustrations.

The exercises are devised to make individual techniques explicit in practical terms, but they are not intended only to give the artist practice in airbrush control. The means of rendering simple geometric shapes can be translated directly into graphic imagery: a cube is a solid object seen as a series of flat planes; various objects from buildings to food packaging are constructed in the same way and can be given the same basic treatment before the identifying detail is added. A sphere corresponds to the moon, a billiard ball or a hot-air balloon. Graded tones and colors can be used to create atmospheric backgrounds with an expression of vast scale; the same ingredients on a small scale conjure the impression of intricate detail.

In this area of airbrushing, the medium plays a vital role. Transparent media, such as watercolor, not only provide different surface textures from opaque gouache, the techniques used to apply them must also be varied. With a transparent medium, every layer of color contributes directly to the final effect, building up the color intensity. With an opaque medium, the initial color is more dense and successive layers obliterate what has gone before.

In watercolor airbrushing, it is therefore the convention to work an image from dark to light. If a dark tone is laid in an area that should be highlighted, it cannot be easily corrected; whereas with gouache a lighter color can simply be sprayed over the previous layer. Airbrushing in watercolor requires absolute accuracy and a degree of forward planning. Highlighted areas are formed mainly by leaving the support showing white, and the surrounding colors gain their brilliance from the whiteness beneath; color mixes can be created on the surface of the support, overlaying blue and yellow, for example, to make green. With gouache, each variation of tone or color is mixed separately, but there is scope for altering the image as it progresses, even so far as spraying an area white and beginning again.

The techniques shown here assume use of an independent double-action airbrush, the most sophisticated type for graphic work, which gives the artist total control over the combination of air and paint supplies. A smooth-surfaced, perfectly white artboard is used as the support. Strong cartridge paper can be used, but the paper must be stretched on a drawing board before paint is applied.

TONE AND COLOR

SPRAYING AN AREA OF FLAT TONE

The airbrush is the ideal tool for creating an area of flat tone; the fine particles of spray create an even density of color and this remains undisturbed because the airbrush does not touch the surface as it lays the medium. Airbrushing a flat tone is a useful exercise to perfect before investigating the technique of tonal gradation. It helps you to achieve control of the flow of air and paint through the airbrush and introduces the basic principles of cleaning and masking the support before you begin spraying; all essential elements of airbrush work however simple or complex the project.

Watercolor or gouache can be used to spray flat color. Gouache is an opaque medium that tends to produce a dense, even surface; the layers of spray cover one another and gradually even out any imperfections. With watercolor, which is transparent, tonal variations can occur that follow the direction of the spraying, causing a slight striping across the surface. With either medium, it is important to obtain the right consistency of paint. It should not be too wet, and the color should be allowed to dry on the support between sprayings.

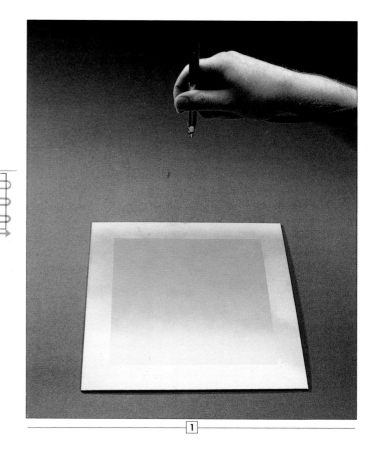

1

Clean the support (see right) and mask the area to be sprayed. Hold the airbrush directly above the board, about 15-23cm (6-9in) from the surface. Starting at the top, spray lightly across the rectangle from side to side, moving gradually down the shape and allowing the spray to extend over the masked edges on every side **1**. After the first layer of color has dried, repeat the spraying. Continue in this way to build up the tonal density required **2**. If a striped effect is apparent, turn the board through 90 degrees and spray across the previous layers to even out the variations. Do not allow the surface to become wet or the support may buckle. When a smooth, flat tone has been achieved, lift the edge of the mask and remove it carefully **3**.

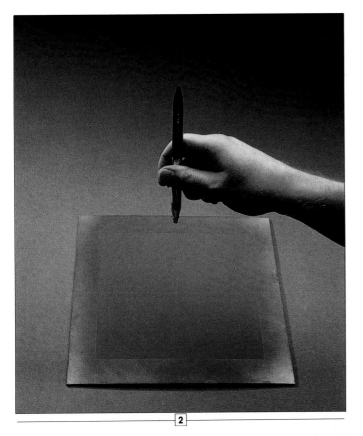

2

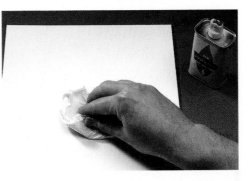

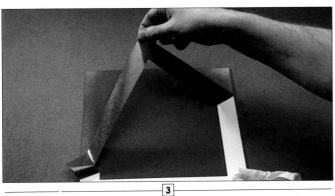

3

For most types of graphic work, the best support for airbrushing is a smooth, white artboard. The lack of graininess allows a perfect surface finish; the brilliant whiteness makes a ground for true effects of tone and color.

An important element of preparation for airbrushing is to ensure that the board is absolutely free of dust or greasy marks, such as fingerprints, which will affect the quality of the airbrushed surface. These can be surprisingly intrusive, even after several successive sprayings. Before any masking or spraying is carried out, the board surface should be wiped over with lighter fuel or a suitable non-greasy solvent.

FLAT TONE

GRADED TONE: USING A TRANSPARENT MEDIUM

The basic technique of laying a graded tone is similar to that of laying a flat tone, but each successive spraying is gradually worked across a larger section of the board rather than the entire area being sprayed at each stage. It is important to develop a smooth transition from dark to light, and this is most easily achieved using a transparent medium — watercolor or ink. A pale tone is created simply by spraying very lightly and evenly. Additional layers of spray gradually build up the mid-tones and darkest areas. You can also experiment with bringing the airbrush closer to the surface to increase the tonal density, but make sure this does not cause an abrupt change of tone between one area and another. There is a natural "overspray," or slight drift of color beyond the main path of the spray, and this helps to soften the transition from dark to light.

The same technique can be used with gouache, but once a solid band of color has been achieved in an opaque medium the tone has reached maximum density and will not darken with further sprayings. It is necessary to mix the tones of one color on the palette and spray them separately (see pages 12 and 13).

This exercise shows the graded tone passing from dark at the top of the rectangle to light at the base. Clean and mask an artboard as for spraying a flat tone. Load the airbrush with color and spray lightly across the top of the board, working from side to side and allowing the spray to pass over the edges of the mask **1**. When the first layer has dried, repeat the spraying to intensify the color at the top of the board, and work down toward the center of the rectangle to create an area of mid-tone **2**. Repeat the process

1

again until a smooth tonal gradation of the required density is achieved **3**. Make sure particles of paint drifting beyond the main area of spray do not build up enough tone to color the palest section too strongly.

When spraying overall tones, whether graded or flat, the path of the airbrush must always extend beyond the masked edges of the rectangle with each pass to avoid inconsistencies in tonal density at the edges of the sprayed area.

2

3

USING A TRANSPARENT MEDIUM

GRADED TONE: USING AN OPAQUE MEDIUM

Clean and mask the artboard as for airbrushing a flat tone. Dilute blue gouache with water and mix it to a milky consistency, and fill the paint reservoir of the airbrush. Working from the top downward, spray a graded tone over two-thirds of the rectangle, following the technique used for spraying with a transparent medium . This color will form the mid-tone in the graded sequence. Mix a darker blue, clean and recharge the airbrush, and spray the top one-third of the rectangle. Repeat until there is a strong band of dark blue

1

2

across the top of the rectangle, which becomes less intense and merges into the mid-tone toward the center of the sprayed area . The final step in the sequence is to apply a paler blue to the lower section of the rectangle, using the original color mixed with white. Turn the board through 180 degrees to do this, and work from the top downward as before. When the bands of color are merged in an even gradation, allow the paint to dry completely before removing the mask ■.

3

This simple exercise graphically demonstrates the different effects of overspraying with a transparent (above left) or opaque (above right) medium. A rectangle of flat-toned gray is first sprayed, followed by a layer of graded orange-red. The gray rectangle is clearly visible underneath the transparent watercolor overspray. In the gouache example, the stronger the build-up of the overspray, the more it covers the underlying color; the gray rectangle remains visible only in the lightest area.

YELLOW AND GREEN FLOWERS PETE KELLY

This illustration uses relatively simple means to create a striking image. Areas of flat color laid against a two-color background are the main elements of the composition. The success of the image depends upon the boldness and clarity of the coloring and a clean elegance in the initial drawing of the flower and leaf shapes. Strong color contrasts are fully exploited and the red detail forms a link between the top and bottom of the image.

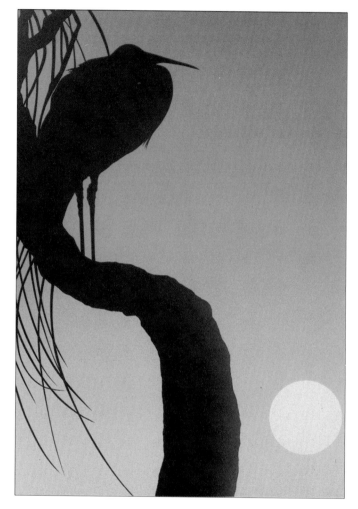

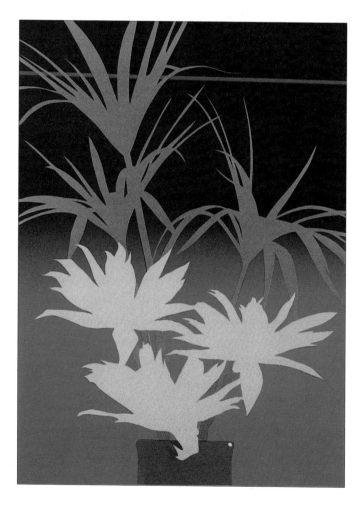

JAPANESE BIRD PETE KELLY

Drawing on the inspiration of oriental paintings, the artist uses graded color to soften the formality of a silhouetted image. This is another example where shapes with minimal interior detail are strengthened by the descriptive quality of the outline between figure and ground. The soft glow of the yellow background is echoed by the warm red-brown gradation in the shape of the tree.

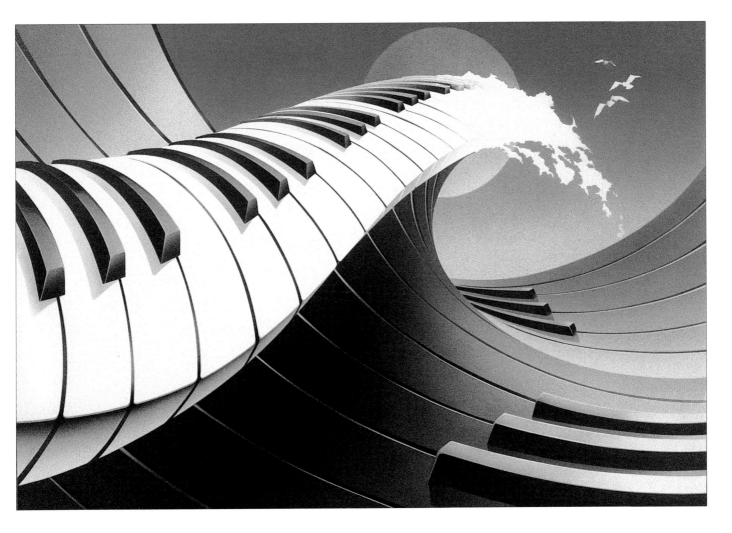

PIANO WAVE BARRY LEPARD

In an illustration which acknowledges the bold approach to form typical of Japanese prints, airbrushed gradations are used to create the dual impression of solid form and fluid movement. The piano keys translated into the curve of a giant wave are defined by heavy tonal contrast, but are also infused with subtle color detail set against the color contrast of sun and sky.

USING AN OPAQUE MEDIUM

AIRBRUSH CONTROL: WIDTH OF SPRAY

The atomized paint spray from an airbrush is channeled through a minute aperture in the airbrush nozzle, but once past the controlled pressure at this point, the distribution of the spray flares into a basically conical pattern. In broad areas of graded tone such as those previously demonstrated, the width of spray is accommodated without any problem, but in more detailed work it is necessary to have sufficient control of the tool to manipulate the spray very closely. It is possible, though rarely necessary, to spray an airbrushed line as fine as a pencil mark. The exercises on these pages are designed to show the range of control of airbrush spraying that can be achieved without use of masking to contain the area of color.

The main factor involved in directing airbrush spray accurately is the height of the airbrush from the support. It is also possible to vary the amount of air and paint allowed to pass through the nozzle of the tool, but this is a difficult control to acquire, as variations of air-paint supplies can cause unexpected spattering or interruptions to the spraying that destroy the surface quality of a finely graded tone.

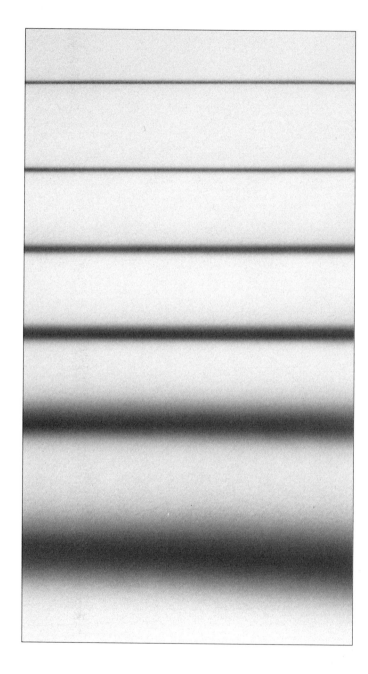

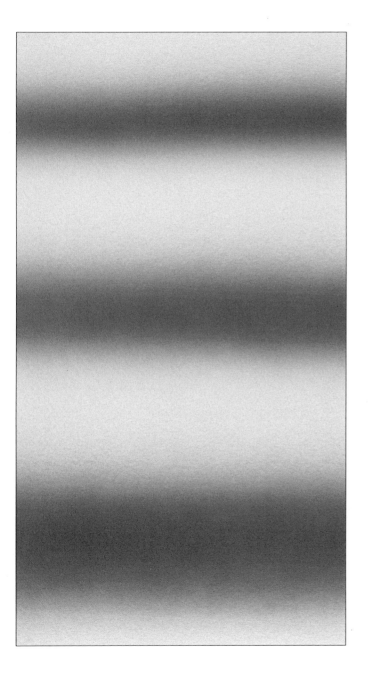

Use a ruler to guide the path of the airbrush at the beginning of this exercise (left). Place the ruler flat on the support across the top of the artboard. Charge the airbrush with color, lift the top edge of the ruler slightly and rest the airbrush nozzle on the ruler edge at one end. Start to spray and draw the airbrush evenly along the edge of the ruler to create a fine line of color. Repeat the exercise, lifting the ruler and airbrush gradually higher from the support with each line of spraying. As the bands of color become broader, dispense with the ruler and spray freehand.

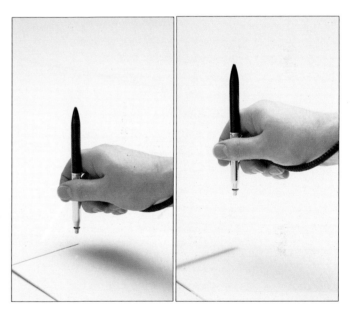

The higher the airbrush is from the support, the less sharp is the edge of the airbrushed line. This area of "overspray" is inevitable and is why masking is used to obtain clean, hard edges in airbrushing. The variations of tone are minimized by keeping the airbrush perpendicular to the surface while spraying; when the airbrush is angled to the support, the overspray tends to drift farther out from the main area of color. Sometimes this extra color haze is almost imperceptible, but it can cause problems when the clean surface of the support is intended to form highlighting.

WIDTH OF SPRAY

DEGREES OF TONAL GRADATION

Depending on the context, tonal gradations in an airbrushed image may cover a large proportion of the painting, as in a sky sweeping to a low horizon, or exist within a contained, small shape, as in a cylindrical machine component. The dark and light tones in those two images might be matched in value, but in the first, the gradation would be spread over a deep area of the picture plane; in the second, the same transition would occur within a depth of perhaps less than 2.5cm (1in). The intermediary tones are less apparent over a smaller area, but there must be a gradation in order to create a smooth-surfaced effect: abrupt contrasts of tone suggest a change of plane or an effect of dramatically harsh lighting.

Graded tone can also be used to create the impression of waves, ripples or a corrugated surface. In the examples on these pages, there is more emphasis on the linear path of the airbrush spray, softened naturally by the diffused spray quality to create mid-tones and highlights.

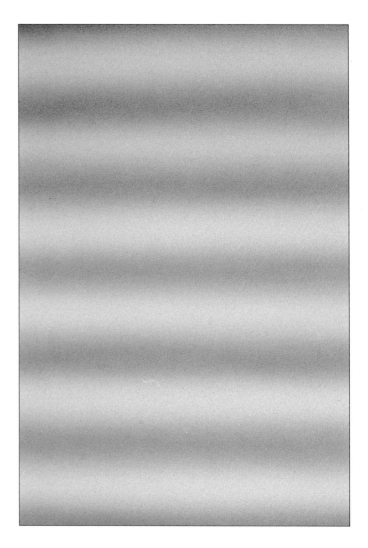

Evenly spaced bands of soft-edged, mid-toned gray create a corrugated effect on the surface. Mask a large rectangle on the artboard and start to spray outside the masked edge at one top corner. Hold the airbrush about 10cm (4in) from the surface; move closer if the spray band is too deep, farther away if it is too narrow. Spray from side to side at evenly spaced intervals.

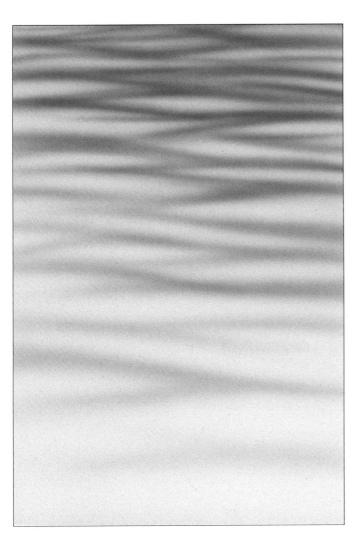

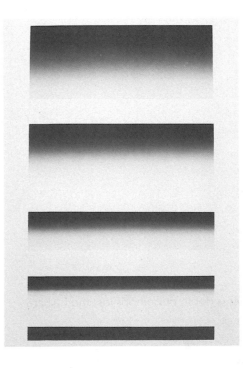

Crossing lines must be airbrushed freehand. Start at the top of a masked rectangle with the airbrush nozzle close to the support. Weave the color back and forth in a rhythmic pattern to create the criss-cross effect. As you work toward the bottom of the rectangle, pull the airbrush back slightly and spray a lighter tone to produce the fading effect as shown.

 To practice control of the transition from dark to light tone, mask a sequence of rectangles increasing proportionately in depth. Work the tonal gradation between the same outer tones in each rectangle to achieve a smoothly graded result within each color band. Similar exercises to this one can be tried working from mid- to light tone, or dark to mid-tone.

DEGREES OF TONAL GRADATION

VIGNETTES: SOFT-EDGED FRAMING

In airbrushing, vignetting is a term commonly used to describe any technique that produces an effect of tonal gradation. A vignette is also, more specifically, a device that frames an image or creates a focal area within a design. The technique of fading the edges of the image area has been a traditional element of such art-forms as portrait photography and book illustration. It adapts easily to airbrushing and can make an effective background for an illustration depicting a single object rather than a pictorial theme. The characteristic qualities of airbrushed color are employed here in a different context from the atmospheric background tones so far examined.

These exercises show three methods of achieving a vignette using a combination of masking and freehand spraying. Depending upon the result required, it is possible to fade the color from the outer edges of the picture surface toward the center, highlighting the image area, or to position the darkest tones at the center and fade them outward, creating a diffused shadow effect. If this forms a ground for a detailed rendering, the area occupied by the object to be represented should be masked.

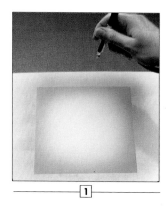

CIRCULAR VIGNETTED FRAME

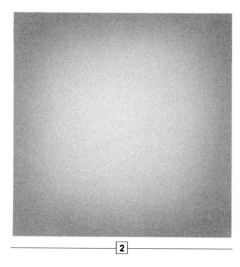

To vignette a squared frame fading inward to a roughly circular centerpiece, apply masking film to the artboard and cut a square mask. Hold the airbrush about 15cm (6in) above the surface and spray in a circular motion, starting just outside the edge of the mask. Gently angle the airbrush toward the mask to avoid too much color falling into the center of the vignette **1**. Keep a smooth action and move in from the masked edges slightly to create the required depth of border **2**.

CENTRAL CIRCULAR VIGNETTE

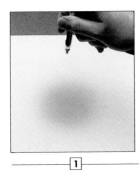

1

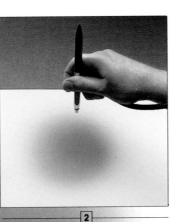

2

3

OVAL VIGNETTE

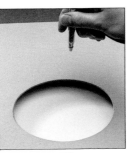

1

2

3

To create a circular central vignette, start spraying directly above the center of the support **1** and move the airbrush in a tight circle, gradually extending the area of spray to the required diameter. Keep the airbrush perpendicular to the surface so that the spray does not drift into the white surround. To intensify the tone, allow the color to dry and then spray the center of the circle again **2**, letting the spray merge subtly into the preceding layer to preserve the graded effect **3**.

To spray an oval vignette, you first need to make a loose mask by cutting an oval of the required size in a piece of cardboard. Place the mask over the artboard, supported at equal height on all sides so that it stands a little above the surface. Spray gently around the cut-out shape **1**. Because the mask is raised, the edges of the oval are naturally diffused by the airbrush spray. Remove the mask and work freehand over the central area to darken the inner tones and develop an even gradation **2** and **3**.

GRADED COLOR: RELATED COLORS

Graded colors increase the range of mood and style that can be obtained by simple tonal gradation. Color is not as important to overall impressions of space and volume as are variations in tone, but many of the most desirable effects typical of airbrush illustration are achieved through clever use of color gradation, from broad sweeps of landscape and sky to the reflected details in the chrome and paint of a gleaming automobile.

It is an easier task to blend colors that have a common element than those which are opposite and unrelated. In this example, yellow and green merge naturally through an intermediate area of yellow-green. A transparent medium provides a soft transition from one color to another. There is no need to mix the transitional hue as a separate third color; the gradation emerges from the overlaid layers of yellow and green.

Green is a secondary color that stands between yellow and blue in the color spectrum. A complete sequence that runs from yellow through yellow-green, green, blue-green to blue can be created in the same way by spraying only with the three main colors (far right, below).

Clean an artboard and mask a deep border on each edge to leave a large rectangle. Fill the airbrush paint reservoir with green watercolor and hold the airbrush about 15cm (6in) above the board surface. Start to spray from one top corner, moving from side to side and gradually working down toward the center of the board **1**. Allow the color to dry and rework the area from the top to intensify the color in the upper section and grade it evenly to a light tone. Clean the airbrush and fill the paint reservoir with yellow

watercolor. Turn the artboard through 180 degrees and repeat the process as before to spray an intense yellow at the top of the rectangle, grading to a lighter color near the center **2**. Allow the yellow to overlap the green, creating a central band of merged color that blends evenly into the main color areas **3**. Keep the airbrush at a consistent distance from the surface throughout to avoid a striped effect, and spray over the masked edges on every side so that there is no uneven color within the rectangle.

RELATED COLORS

GRADED COLOR:
OPPOSITE COLORS

Red and blue are primary colors, both strong hues that have no common ingredient and which create a distinct secondary color – purple – when mixed. A subtle gradation from red to blue can be achieved in exactly the same way as the yellow/ green transition demonstrated in the previous example. Using watercolor, you can create the third "mixed" color, the purple band, by overlapping transparent layers of red and blue.

This exercise takes a different approach, using opaque gouache to spray areas of flat, intense color that merge abruptly, the line where they meet being softened by the diffusion of the airbrush spray. This avoids the hard-edged effect that would occur if the two colors were separately masked and sprayed, but the result is bolder and more dramatic than the delicate sequence of closely related colors. These colors are of equal density and form a visual balance that contrasts with the light-to-dark effect of the yellow/green example.

Clean an artboard and mask a large rectangle, as for the previous exercise. Mix red gouache with water to the consistency of milk and fill the paint reservoir of the airbrush. Spray an area of flat color across the top half of the board, using repeated sprayings to build up the color density **1**. Allow the color to dry between applications. As you reach the half-way point on the board, angle the airbrush slightly toward the top edge to avoid red paint drifting into the area that will be sprayed blue. Clean the airbrush and charge it

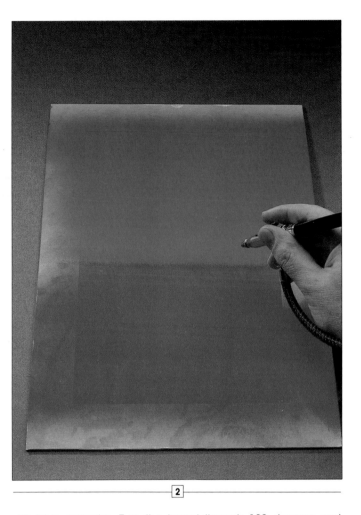

2

with blue gouache. Turn the board through 180 degrees and repeat the spraying process as described to lay down a flat area of blue **2**. Allow the blue to finely overlap the edge of the red section but try to avoid creating a distinct color mix. If the junction becomes ragged, work over it again with a light spray of both colors. Because the hues are at maximum strength, additional spraying should not interfere with the even surface quality of the areas of flat color.

 The narrow band of hazy mixed color where the two sections merge is minimized by spraying each color from the outer edge downward, achieved by turning the support for the second spraying, with the airbrush angled into the area being sprayed. Spraying upward from the bottom of the rectangle would encourage the spray to drift into the area above, coloring the red section with a faint layer of blue.

OPPOSITE COLORS

COLOR GRADATION

These airbrushed examples take the previous exercises one stage farther and give a direct comparison between the use of a transparent and an opaque medium. The broader area of the color spectrum, through crimson, red, orange, yellow, green, blue and violet can be sprayed with watercolor without individual spraying of the orange and green bands; these are provided by overspraying red with yellow and blue with yellow respectively, as explained in the annotation. At each end of the spectrum there is a merging of the colors, but the intermediate mixed hue is not as distinct as with the orange and green. In the gouache sample, all seven colors are sprayed as separate bands.

The possibility of mixing colors on the support rather than in the palette should always be considered when the masking sequence is planned for a particular image. If it is possible to create secondary colors by overspraying, this can save time and additional work on cutting and replacing masks.

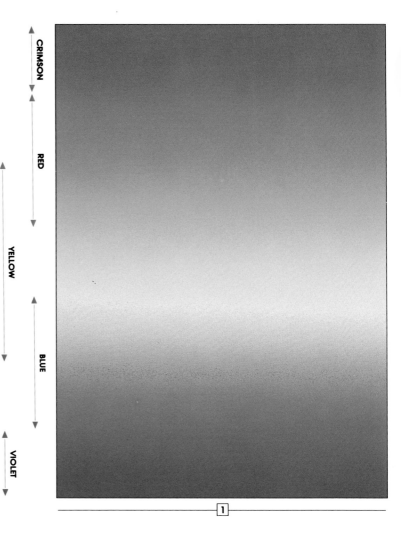

CRIMSON
RED
YELLOW
BLUE
VIOLET

1

Using watercolor, start at the top of a masked rectangle and spray a band of violet. Recharge the airbrush with blue and spray a broader band below the violet, allowing the colors to merge slightly. Turn the board and spray again from the top with crimson, then below this a band of red. To complete the spectrum, spray yellow across the center of the rectangle, allowing it to overlap the red and blue on both sides to create the orange and green.

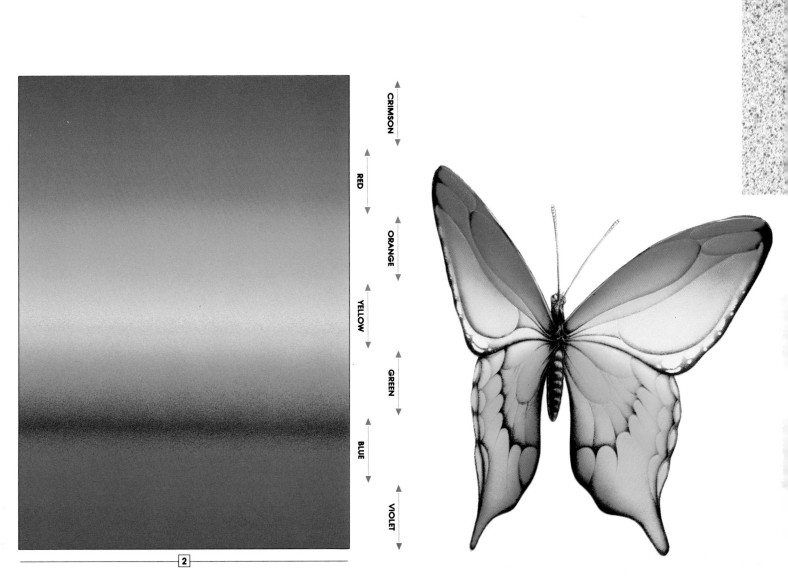

CRIMSON

RED

ORANGE

YELLOW

GREEN

BLUE

VIOLET

2

Using gouache, spray each band of color in turn, mixing the secondary colors of orange and green in the palette. Start at the top of the rectangle with violet and move on through blue and green. Turn the board and work from the top again to spray crimson, red, orange and yellow in sequence. Keep the colors as clean as possible and spray lightly at the joining of the color bands to create the softly merged effect.

BUTTERFLY JOHN CHARLES

This illustration of a butterfly uses the technique of color gradation with a transparent medium. The strong outlines of the shape contrast with the rainbow coloring; they serve to control the fluid effect of the interior color and allow the artist to build up the decorative detail. The graded colors merge gently, giving a luminous quality typical of transparent airbrushing.

COLOR GRADATION

MASHUKO PETE KELLY

This is a perfect example of the mood and atmosphere that can be created by controlled effects of graded tone and color. The heavy black and cool grays create a tonal contrast that defines the image strongly, offsetting the subtle, warm effect of the color gradation in sky, water and land. There is a carefully judged balance of tones throughout.

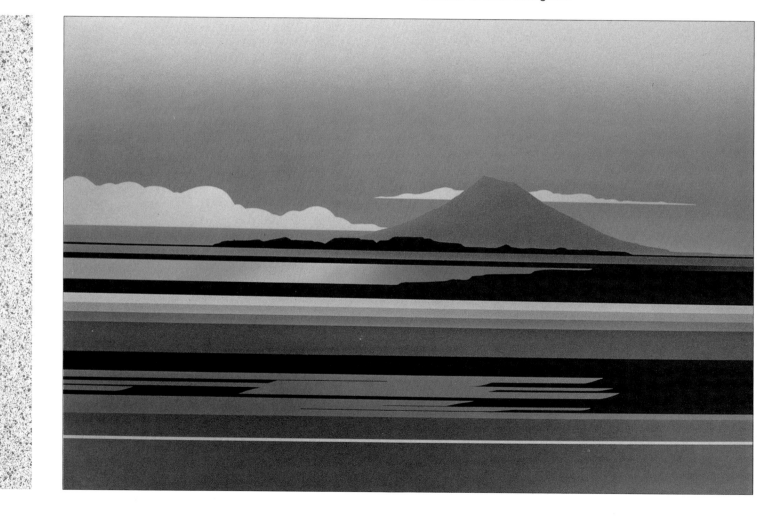

FIGHTER ATTACK TREVOR WEBB

The vivid activity of this space-age image offers a very different mood from the previous example, but the impact of the illustration equally depends upon clever use of color and tonal gradation, in the fiery sky and boiling clouds. The soft texture of the clouds forms a striking backdrop and an effective contrast to the sharply detailed rendering of the aircraft.

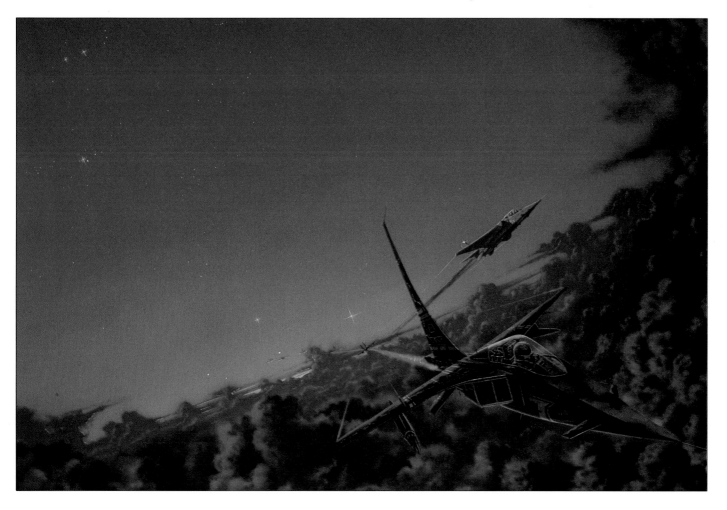

COLOR GRADATION

SHAPE AND VOLUME: FLAT PLANES AND CUBES

Tone is the main element that creates an effect of three-dimensional form in a two-dimensional image, and the principles of tonal modeling can be effectively demonstrated using basic geometric units – the cube, sphere, cylinder and cone – as shown in the following pages. A great variety of man-made objects and many organic forms are basically composed of flat planes and curved surfaces, relating to these simple shapes.

These examples show a cube as if lit from a light source above and slightly to the right of the viewer. The pattern of light and shade defines the form and the degree of tonal contrast suggests soft or harsh lighting. The initial drawing of the cube is film-masked and each plane is unmasked and sprayed in sequence, using watercolor, working from dark to light.

In the example of a transparent cube on the following page, the effect is rendered by means of overlapping planes. To achieve the delicacy of tonal gradation while maintaining a clean-edged shape, in the second stage of the sequence sections of mask are removed and replaced as each plane is completed.

FLAT TONE

The volume of a cube can be simply rendered by areas of flat tone ranging through dark, medium and light. Draw the outline of the cube and apply masking film. Cut the mask along all the lines of the drawing. Lift the masking film from the left-hand side of the cube and spray a dark tone **1**; then remove the second mask section and spray a mid-tone on the right-hand plane **2**. Finally, lift the mask on the top section of the cube and spray the light tone **3**.

GRADED TONE

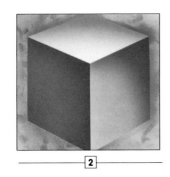

A bright, evenly spreading light illuminates the top plane and front edge of the cube, but does not create strong shadows. The spray sequence is the same as in the previous example, but uses graded tones on each plane: mid- to dark tone on the left **1**; light to mid-tone on the right **2**; and a slight shadowing on the receding edges of the horizontal plane **3**. Move the airbrush closer to the surface to control the area of spray in the shadow detail.

TONAL CONTRAST

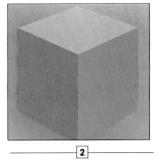

A strongly angled light source produces areas of intense contrast and sharply defined edges. Lift the mask sections and spray in the same sequence as for the previous example. Work from dark to light, intensifying the tones of the left-hand plane and the outer edge of the right-hand side **1**. Apply tone from the top corner of the horizontal plane **2**, making sure color does not drift into the light area below as this would deaden the contrasts **3**.

3

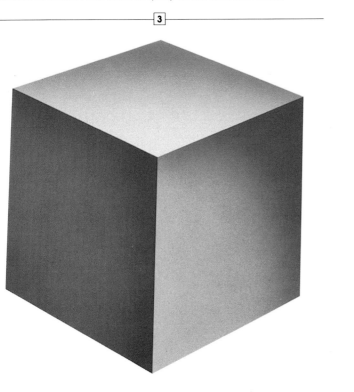

3

FLAT PLANES AND CUBES

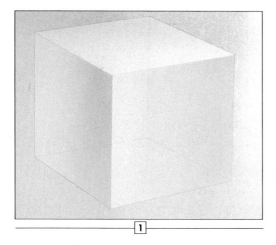

Draw a cube showing the outlines of all six planes and apply masking film. Following the steps shown on the two previous pages, render the forward-facing planes of the cube with lightly graded tone to create a solid effect **1**. Position a clean piece of masking film over the cube, overlapping the background mask still in place. Cut along the lines of the three inner planes. Put a hinge of masking tape on the left-hand vertical line and lift the mask on the back plane of the cube. Spray a graded tone, passing from mid-tone on the left to light tone on the right **2**. When the color is dry, replace the mask. Hinge and lift the mask section covering the inner right-hand plane. Spray mid-tone on the right, grading to light tone on the left **3**. When dry, replace the mask. Lift the mask from the floor of the cube and spray mid- to light tone from the back to the front **4**. Remove all the masking film **5**.

TRANSPARENCY IN A THREE-DIMENSIONAL SOLID

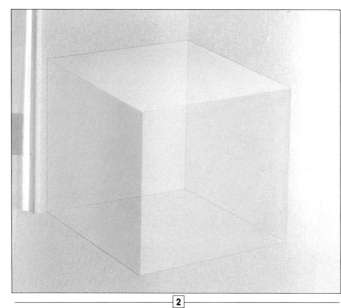

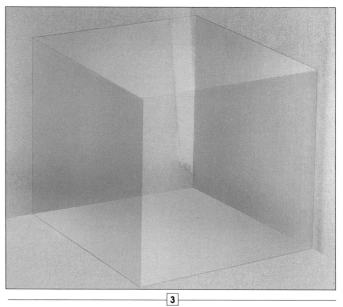

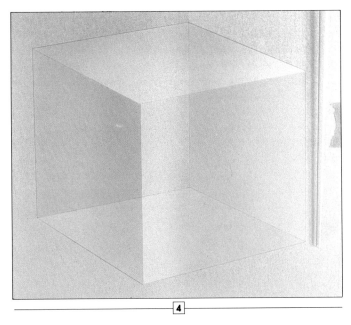

4

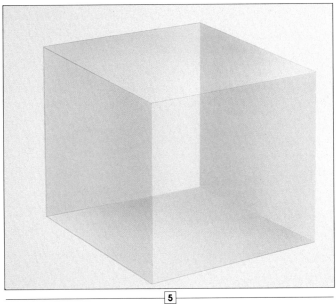

5

The basic methods for airbrushing a cube apply to other forms composed of flat planes such as the plank shape (top). For a cut-diamond effect (above right), the leading edges are highlighted to define the main facets. Heavy shadowing on the inner faces of a cube (above) creates the impression of a hollow box.

SHAPE AND VOLUME: CIRCLES AND SPHERES

Airbrushing a sphere is a more difficult exercise than it may at first appear, requiring careful manipulation of the airbrush to spray the tones freehand within a single masked area. The transformation of a circle into a sphere depends upon the correct relationship of highlight and shadow. The highlighting follows the curvature of the sphere and is either roughly circular when directly lit, or a crescent arc suggesting reflected illumination. Shadow areas enclose the main highlight or underline the crescent shape. These exercises relate not only to illustration of objects that are actually spherical, but also to any surface that curves in all directions and can be seen as having a similar pattern in the distribution of light and shade across the curve.

Lighting from behind the sphere creates a haloed effect, with the darkest tone at the center of the circle, whereas a directly frontal light source has the opposite effect. A strong sidelight defines only one highlight area strongly contrasted with the shadow. Double highlights falling within the shape or at the outline emphasize the effect of roundness and create a more solidly three-dimensional illusion.

Draw a circle 10cm (4in) in diameter and cover the artboard with masking film. Cut and remove the circular section of the mask. Hold the airbrush at right angles to the surface 5cm (2in) above the center of the circle. Start to spray and gradually pull the airbrush upward to increase the area of spray **1**. Repeat until the center is a deep tone, grading evenly to light at the edge **2**.

BACKLIT SPHERE

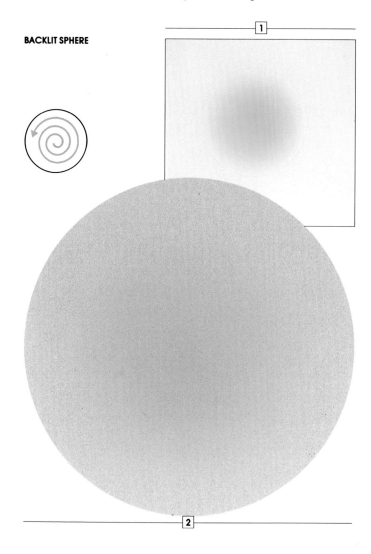

Mask the circle as for the first exercise. Hold the airbrush above the masked edge on the upper right of the circle. Move it evenly back and forth, working in an arc as you approach the left-hand side **1**. Allow the paint to dry and repeat the spraying to create a graded tone curving around the highlight **2**. Respray the right-hand side of the circle as necessary to intensify the tonal contrast.

SIDELIGHTING

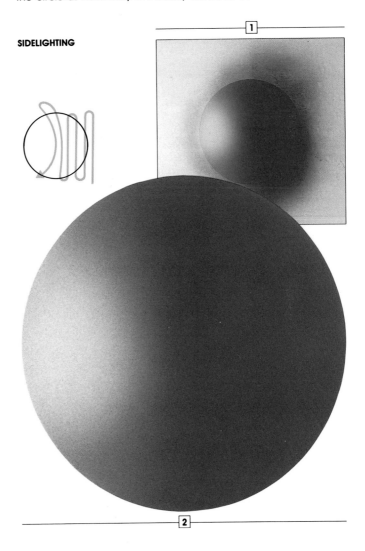

CENTRAL HIGHLIGHTING

Mask a circle as for the previous exercise. Hold the airbrush directly above the masked edge about 5cm (2in) from the surface. Start to spray in an even motion around the circumference of the circle **1**. Allow the color to dry and repeat, holding the airbrush higher to create a broader area of spray **2**. Judge the width of spray carefully to maintain the central highlight area.

CIRCLES AND SPHERES

Mask the circle as for the first exercise. Spray all around the edge of the mask, allowing the spray to create a light tone just inside the circumference of the circle. Work over the lower half of the circle, moving the airbrush through an inverted arc to create the mid-tone **1**. Repeat to darken the lower edge, maintaining the crescent pattern of the spray **2**.

TOPLIT SPHERE

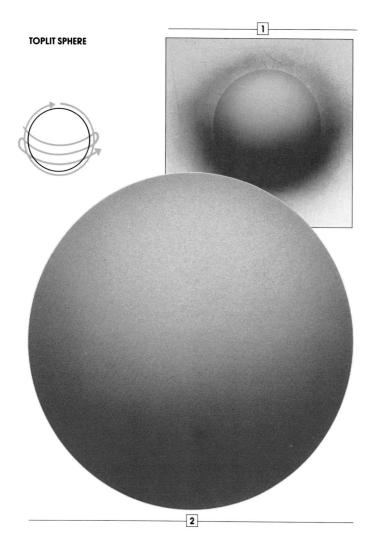

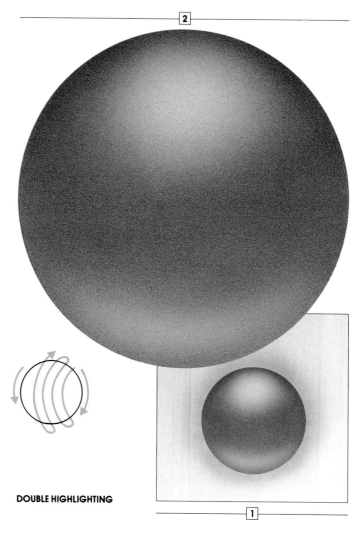

DOUBLE HIGHLIGHTING

Mask the circle as previously and start to spray at the top edge of the circle, about 5cm (2in) from the surface. Move the airbrush elliptically to lay a thin band of color around the upper curve, broadening the area of spray toward the center of the circle. Leave a crescent-shaped highlight at the lower edge **1**. Repeat to build up the tones. Finally, spray the lower edge very finely **2**.

Mask the circle and spray a curving band of color through the center. Spray around the top edge, holding the airbrush no more than 5cm (2in) from the surface to control the width of spray **1**. Work in a roughly circular motion to define the highlight area at the top, leaving a curving highlight at the base **2**. If striping occurs, hold the airbrush slightly higher to diffuse the color.

**DOUBLE HIGHLIGHTING
WITH EDGE HIGHLIGHT**

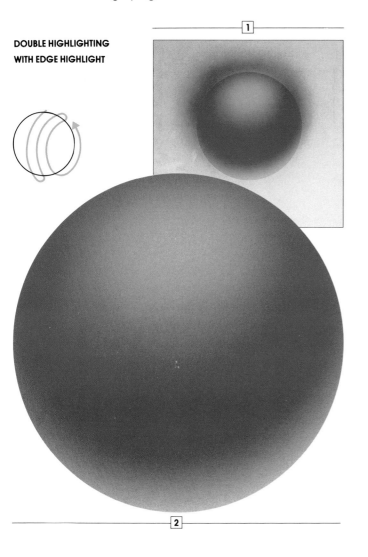

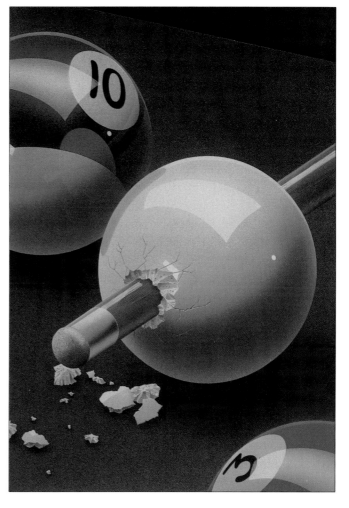

SHOOT POOL BRIAN JAMES

The capacity of the airbrush to produce an illusionistic finish allows the artist to depict an impossible event with startling reality. This witty illustration employs two basic geometric shapes – sphere and cylinder – and with subtle use of graded tone and color, sharp highlighting and careful attention to detail creates an impressively polished image.

CIRCLES AND SPHERES

SHAPE AND VOLUME: CYLINDERS AND CONES

Although a curved surface is an essential component of a cylinder or cone, both of these shapes differ from the sphere in that the curvature is directional, and the flat plane represented by the cross-section of the form is also a definitive part of the structure. As with the sphere, the highlights and shadows that render a cylinder or cone three-dimensional relate directly to the outline of the basic shape. These exercises, all executed in watercolor, show how by varying the position and relative width of the tonal gradation, different effects can be used to describe the volume and contour of each form, including a hollow cylinder. The degree of highlighting also suggests the reflectiveness of the surface texture.

The cylinder is a particularly useful form to master in airbrush work. It is the basis of many forms and objects that commonly occur in illustration work and pictorial composition — it can be seen as the underlying form of a space rocket or a human limb, for example, as well as more directly forming the structure of many types of machine parts and industrial or architectural elements. The cone, though a less ubiquitous form, demonstrates an additional visual element.

SIMPLE SOLID

CENTRAL HIGHLIGHTING

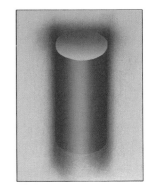

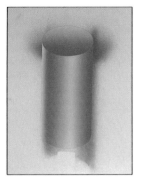

SIMPLE SOLID

Draw a cylinder 10cm (4in) long, mask the artboard and cut along all the outlines of the drawing. Remove the mask from the long side of the cylinder. Spray a graded tone, moving evenly from dark on the left to light on the right-hand side. Remove the mask from the cross-section of the cylinder and spray a graded tone, lightening toward the front edge of the elliptical plane.

DOUBLE HIGHLIGHTING

CENTRAL HIGHLIGHTING

Mask the drawing as described in the first example. Remove the larger section of the mask and spray the sides of the cylinder with two areas of graded tone, working from dark tone on the edges to light at the center. Remove the second mask section and spray the top plane of the cylinder in the same way as previously, working from dark tone at the furthest edge to light at the front.

DOUBLE HIGHLIGHTING

Prepare and mask the drawing as before. On the sides of the cylinder, spray two bands of dark tone leaving a broad highlight off-center at the front of the cylinder and a narrow band of highlighting on the left-hand edge. When the color is dry, replace the mask section and remove the mask from the top plane. Spray dark tone at the front edge, grading to light at the back.

HOLLOW CYLINDER

HOLLOW CYLINDER

Mask the cylinder as described and remove the main section of mask. Spray the sides of the cylinder with three bands of dark tone alternating with bands of highlighting. Replace the mask section when the paint is dry and remove the upper piece of masking film. To create the hollow effect, spray the ellipse with vertically graded tone, placing the main highlight at the center.

CYLINDERS AND CONES

SIMPLE SOLID

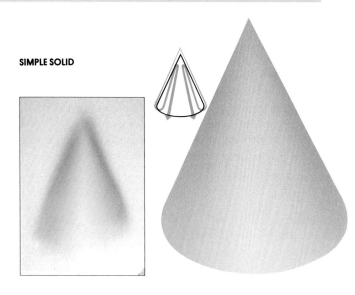

Draw the cone shape and mask the artboard. Cut around the outline of the cone and remove the mask section. Spray graded tone down both sides of the cone, starting close to the surface at the top and drawing the airbrush upward to increase the width of spray toward the bottom. Repeat as necessary to intensify the color, allowing the paint to dry between sprayings.

DOUBLE HIGHLIGHTING

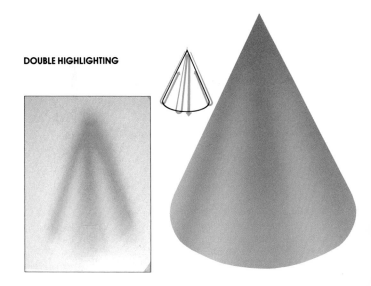

Mask the cone shape as for the previous exercise. Spray a central band of tone, starting near the surface at the top and raising the airbrush slightly toward the bottom of the shape. Spray down both sides of the cone in the same way, slightly inside the masked edge on the left and over the edge at the right-hand side. Repeat to build up the balance of dark and light tones.

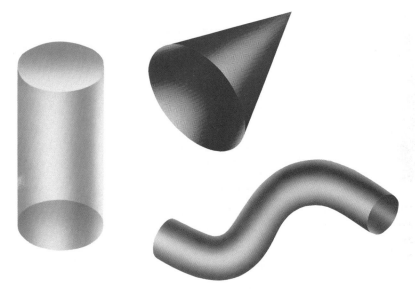

Different results are achieved by varying the tonal distribution within the simple outlines of a form. In a transparent cylinder (far left) both elliptical sections are visible, the lower one overlaid by the spraying of the cylinder sides. Dark tone on the inner edge of the base of a cone (above left) creates hollow interior space. In a snaking cylinder (left), highlights follow the outline.

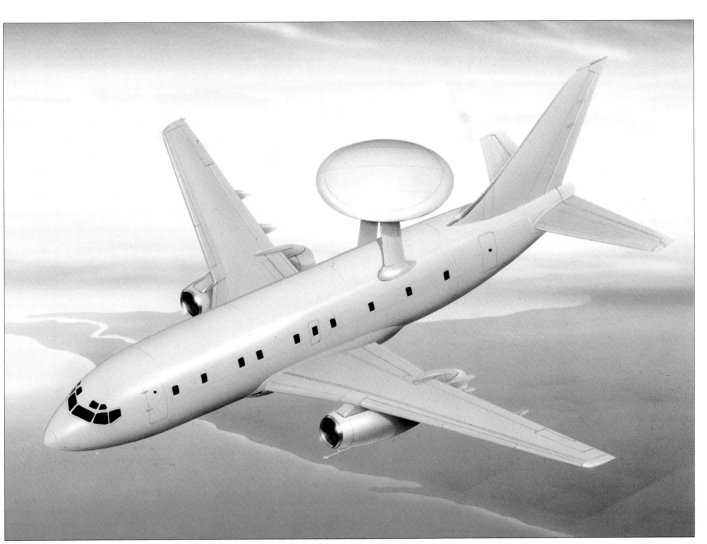

"AWACS" BRETT BRECKON

This illustration is an example of the artist's expertise being used to visualize a proposed Airborne Warning and Control System (AWACS) aircraft. Graded tones are applied to the basically simple shapes of the aircraft components, such as the cylindrical body of the plane, building up a complex picture of a sophisticated machine. Subtle coloration in the background adds to the effect.

CAST SHADOWS: POSITIONING OF OBJECTS

Cast shadows occur when an object is standing in the path of a beam of light and, providing the object is fully solid, are soft or heavy in direct relation to the strength of the light source and whether it is focused or diffused. A shadow is a means of locating an object within its surroundings. When the object stands firmly on a flat surface, the shadow is thrown directly from its base and echoes its outline, though the shape may be elongated or foreshortened in the shadow. If the object is suspended between the light source and a flat plane, the shadow is detached and its position indicates the distance of the object from the surface.

A strong light source tends to produce hard-edged shadows with little tonal variation, whereas under softer lighting the shadow may be subtly graded from dark to light. A diffused light causes faint, vignetted shadowing. All these elements contribute to the realistic effect of an image, but the artist can also play with shadow effects to introduce an element of ambiguity – developing a systematic overlapping of shadows that indicates more than one light source, or a complex shadow pattern between close objects.

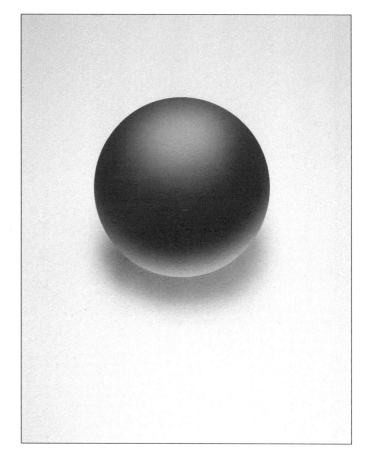

BASE SHADOW:
SOLID SPHERE

Airbrush a double-highlighted sphere following the steps explained in the exercise shown on page 37. Remove the background masking and, when the paint is completely dry, apply a mask to the completed sphere. Spray lightly around the lower edge of the mask, repeating the spraying to build up an elliptical area of graded tone. Remove the masking on the sphere when the shadow area has dried.

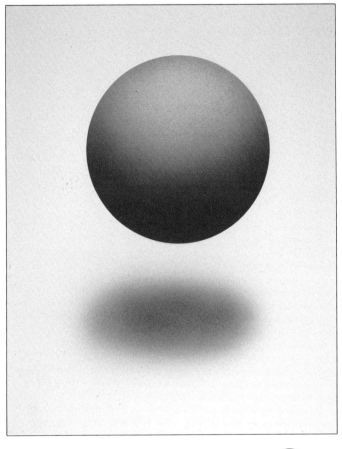

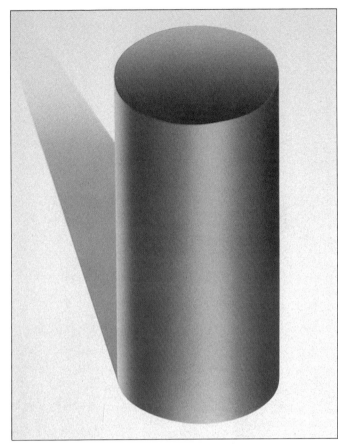

DETACHED SHADOW:
FLOATING SPHERE

Follow the steps explained on page 36 to airbrush a sphere with shadowing on the underside. Remove the background masking and apply a mask to the airbrushed sphere. Working freehand, spray the cast shadow about 2.5cm (1in) below the base of the sphere, starting at the center of the shadow area and moving the airbrush in a tightly elliptical motion. When dry, remove the circle mask.

ELONGATED SHADOW:
EFFECT OF DISTANCE

Airbrush a highlighted cylinder as shown on page 39. When dry, remove background masking and draw a receding shadow angled from the base of the cylinder to a vanishing point at the center of the artboard. Cover the whole board surface with a fresh film mask; cut and lift the masking on the shadow area. Spray a graded tone from dark to light, working outward from the edge of the cylinder.

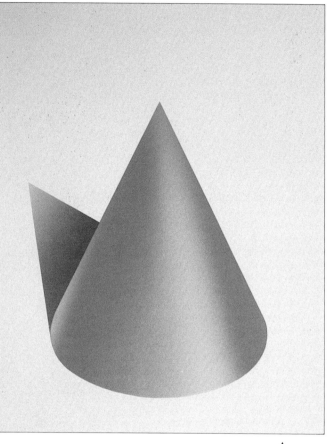

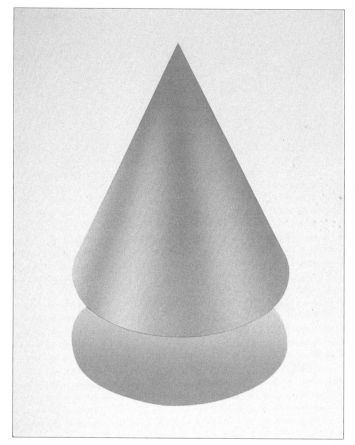

TRUNCATED SHADOW:
HARSH LIGHTING EFFECT

Airbrush a cone with a single highlighted area following the steps explained on page 40. Replace the mask section previously removed from the cone. Cut the shape of the point of the cone out of the background mask, positioned at an angle to the left-hand side of the cone. Spray the shape with graded tone, placing the darkest tone at the edge of the cone and softening the density of tone toward the point of the shadow area.

HARD-EDGED SHADOW:
SUSPENDED SOLID

Follow the instructions on page 40 to airbrush a cone with double highlighting. Replace the mask section over the completed cone and cut an elliptical shadow out of the background masking below the cone. Position the shadow area so that it is partly overlapped by the base of the cone. Spray a graded tone on the shadow area, showing dark tone in the foreground gradually receding to light.

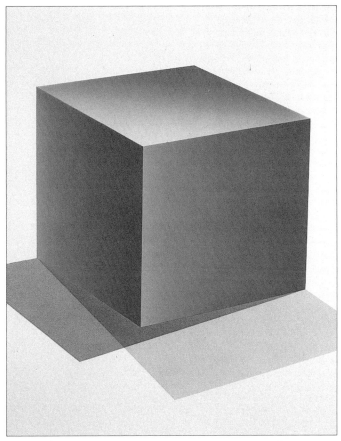

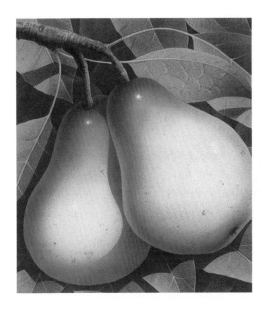

OVERLAPPING SHADOWS:
DUAL LIGHT SOURCE

Draw a cube in outline and define the shadows falling forward from each side-plane of the cube. Mask and spray the cube with graded tone as shown on page 31. Remove the background mask and lay a fresh piece of masking film. Cut and lift the mask on the left-hand shadow area and spray a graded tone. Replace the mask section and repeat on the right-hand side, using lighter tonal gradation.

TWO PEARS BRIAN McINTYRE

In this stylized illustration, cast shadows are used to isolate and clarify the forms. A hard-edged shadow between the two pears emphasizes the contours and throws them into relief, one against the other. In the same way, dark shadows on the leaves create a more complex composition while framing the central shapes against the background.

TECHNICAL CORRECTIONS

The perfect surface finish of airbrushing makes it desirable that no corrections should be included that may interrupt the evenness of the spray quality. However, accidents do happen, and it is not always necessary to start again when an error occurs.

It is easier to make an alteration in a gouache painting than when using a transparent medium. It is possible simply to overspray the area until the desired strength of color is built up to cover the error below. The transparency of watercolor is a drawback to making corrections invisibly. Any alteration to the surface shows an edge where the color is cleaned away; if the area is simply oversprayed, the original color still shows through the paint. The technique of lifting watercolor while it is still wet is therefore best suited to a small masked area where all the paint can be cleaned off, rather than a section of the image within a broader spread of color where the edges of the correction may remain visible.

Acrylic paint is a useful medium for correction. Overspraying in white provides a smooth, fresh surface and acrylics dry to a waterproof finish that can be oversprayed without ill effects.

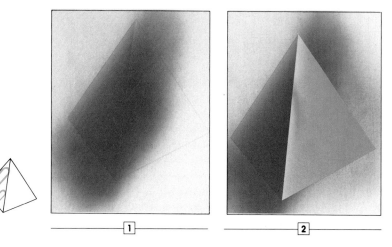

1

2

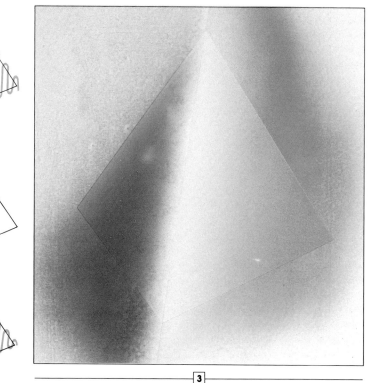

3

This example shows where an error in masking technique has allowed dark tone to cover an area that is intended to be highlighted **1**. The left-hand area of the pyramid is correctly sprayed and when dry, covered with masking film. This and the background masking precisely frame the area containing the unwanted tone, which is now sprayed over with white. The spraying is repeated until the highlight area is completely covered with opaque white and the right-hand face of the pyramid is lightened over all **2**. The white paint must be allowed to dry completely before the area can be resprayed in the original color **3** to gradually form a graded tone, darkest in the right-hand corner of the shape and becoming lighter toward the leading edge of the pyramid **4**. White acrylic paint can be used to make corrections in this way, forming a waterproof finish which may then be oversprayed with watercolor or gouache.

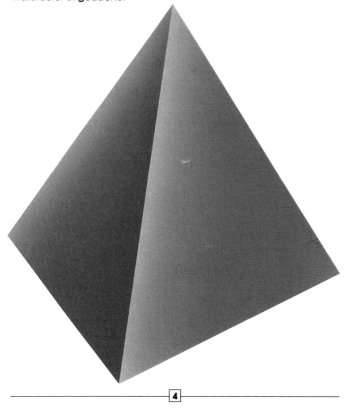

Watercolor can be lifted from the surface of a smooth-textured support before it is fully dry using a cotton bud (above left). This technique is best applied to small areas of detail because the overspraying of the required color, being transparent, will not disguise a correction in a broad area. To correct a color bleed, a fringed edge of color caused by paint penetrating under the mask, allow the paint to dry completely and then scrape it away carefully with an X-acto knife (above right).

TECHNICAL CORRECTIONS

SURFACE QUALITIES: SPRAYING ON TEXTURED SUPPORTS

The visual impression of a graphic image depends not only upon the airbrushing techniques applied but also on the surface qualities of the support – the ground on which the airbrush spray is laid. For much illustration and design work, clarity and precision are the essential requirements, and a smooth surface finish is needed that allows absolute control over broad tonal gradations and fine detail. A heavily grained support can, however, supply special qualities that suit the mood or style of a particular image. A pronounced grain, for example, is appropriate to a loose painterly style, evoking associations with hand-painted works on canvas.

Only by experiment can it be seen how a textured support may be suited to a particular style of work, as there may be technical problems that should be taken into account. Masking film does not adhere tightly to coarse textures so it is impossible to achieve a crisp, hard edge. Cardboard or acetate loose masks can be used to give a softened effect to the image. On a heavily grained paper, the airbrush spray may accumulate unevenly or trap loose fibers from the paper, causing the color to appear flecked or mottled.

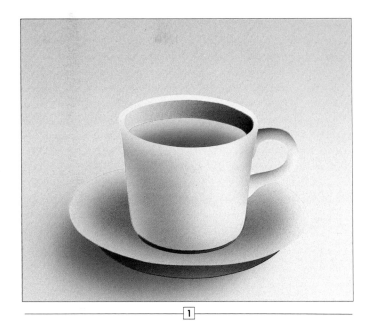

The same image applied to five different supports demonstrates the distinct variations of surface quality. A smooth artboard such as CS10 is the most commonly selected ground for airbrushing, giving a sharp, clean image **1**. A slightly grainy machine-made paper **2** softens the effect and a similarly grained laid Ingres paper **3** gives an impression of having been screened. In heavily textured watercolor papers (**4** and **5**) the smooth gradation of tone is interrupted by the surface texture, and edges begin to be blurred where the tonal contrast is not pronounced – as at the top of the cup and edges of the saucer. The examples show a heavy machine-made Fabriano paper **4** and a hand-made sheet **5** with a coarse, uneven grain. Papers are more absorbent than artboard and should be wetted and stretched on a drawing board, secured on all sides with gummed tape, and allowed to dry before any paint is applied. When dampened by the airbrush spray, stretched paper dries flat; unstretched sheets will buckle.

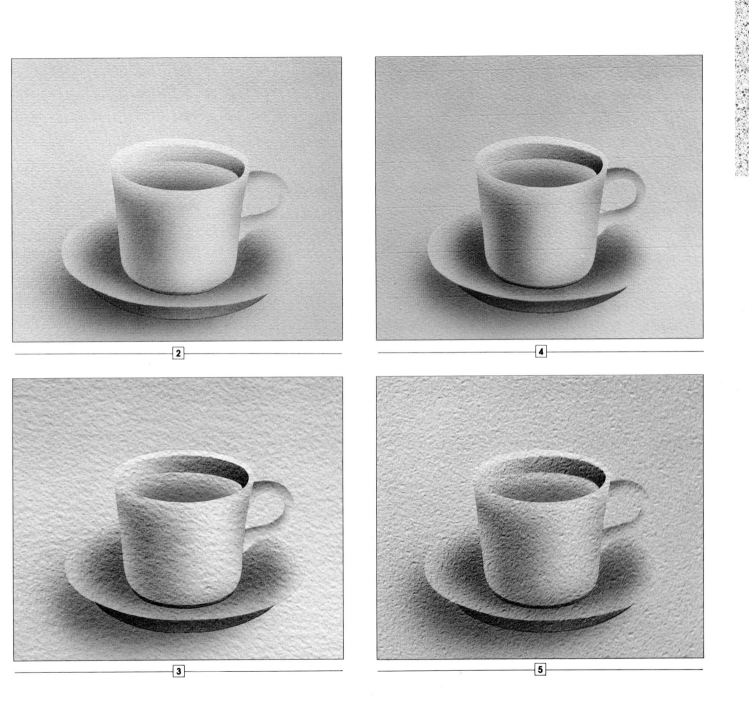

SPRAYING ON TEXTURED SUPPORTS

SURFACE TEXTURES: FABRICS

In many types of materials, the characteristic surface texture that conveys the nature of the substance can be simulated by reproducing its tonal values accurately. Emphatic textures, such as heavy fabric weave or pitted metal, present particular problems for the airbrush artist that may need to be solved by special techniques. But with any relatively smooth surface – many types of fabric, plastic or metal, for example – the tonal gradation describes its hardness or softness and the light-reflecting properties that make it very shiny or dull matte, or somewhere in between.

In these airbrush renderings of two different types of fabric, a shiny, silky texture is represented by a complex system of folds, hard-edged tonal contrasts and pure white highlights. In the green fabric the folds are bulkier and the contrasts much more discreet with no strong highlighting, a combination of elements suggesting a dense velvety material.

In both examples, film-masking establishes the hard-edged effect of a deep fold, but the tonal variations are mainly described through freehand spraying. This needs careful control of the height of the airbrush and paint/air ratio.

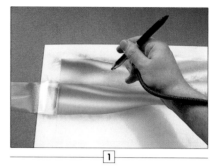

SHINY FABRIC TEXTURE

Mark the image area on the artboard and draw in the lines of the fabric folds. Apply masking film and cut along the lines of the main folds. Lift one section of the mask at a time – it can be hinged to the border with adhesive tape for easy replacement – and work freehand to develop controlled gradation with strong contrasts **1**. Complete each section in turn, keeping the tonal variations consistent **2**. When the masking film is removed, the hard edges indicate heavy folds, contrasting with the softer freehand effect **3**.

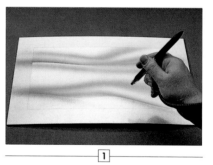

MATTE FABRIC TEXTURE

Prepare the drawn image and mask it as above. Cut the lines indicating the main folds and peel back the central section of the mask. Airbrush along the masked edges to create the hard lines of the deep folds **1**. Remove all the masking from the image area and work freehand across the rectangle to build up softly graded color overall **2**. When the drapery is effectively rendered, spray a thin glaze of color over the whole surface to knock back highlights and soften contrasts **3**.

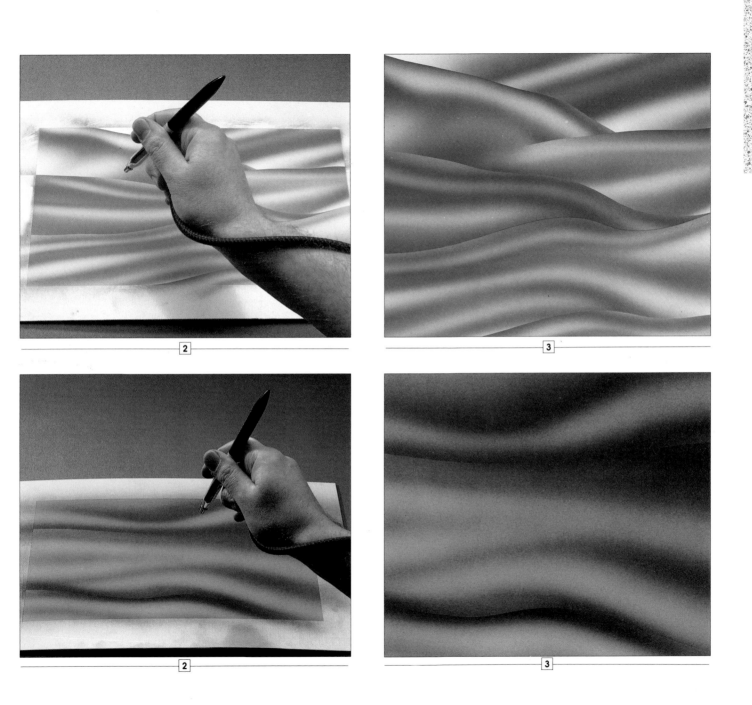

SURFACE TEXTURES: FABRICS

TEXTURE AND COLOR: STONE

Surface texture plays a major role in the recognition of particular types of materials, natural and man-made; and in the case of different qualities of stone, the color is a specially important visual factor. The examples shown here demonstrate methods of using graded tone and color to give a precise rendering of characteristic stone textures: a mottled pebble, a striated stone, and the elegant patterning of veined marble. The textures are overlaid on graded tones and colors that establish the volume and contour of the object.

The linear effects of striation and veining can be represented through carefully controlled freehand work with the airbrush spray. The mottled surface of the pebble in the first example introduces a special technique of airbrushing called spattering, which creates heavier particles of color. Certain types of airbrush can be equipped with a spatter cap, a nozzle attachment which disrupts the evenness of the spray to cause this effect. Using an independent double-action airbrush, the same effect can be achieved with the standard nozzle by lowering the proportion of air to medium, thus producing a coarse, uneven spray pattern.

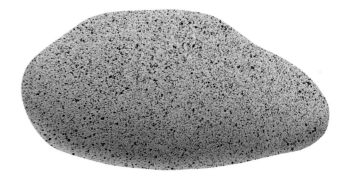

Airbrushed examples of two pebbles demonstrate two very different but equally effective ways of simulating natural stone textures and coloring. The mottled effect so often seen in stone is rendered directly with spattered spray. This is the final stage of the airbrushing: the shape and contour of the pebble are first built up using graded tones of gray, shadowing the underside of the object and creating a fine highlight on the lower edge as well as light tone on the upper side. Rock striations in a brown pebble (below) are represented with fine lines of graded tone airbrushed freehand within the masked outline. Slight shadowing indicates the overall contour of the curved form.

The soft veining and subtle gradations of color in a piece of marble lend themselves to airbrushed texture. The volume of the marble slab is first established with graded tones on each plane (see pages 30-33), and the color detail is applied over this basic form. Loose masks can be used to distinguish the areas of yellow and blue-gray graded tone. The lines of the veining are airbrushed freehand with the tool close to the surface of the board, and softened by further applications of light tone.

TEXTURE AND COLOR: STONE

PROJECT: COMBINED GRADATION TECHNIQUES

The illustration on this page has been specially created to combine the individual techniques previously demonstrated. The image of a juicy apple on display in a sea of sand is in the semi-surrealist vein that works particularly well in airbrush art. The smooth surface quality is a unifying factor, bringing a heightened sense of realism to subject matter that exploits the unexpected.

As well as technical control of the application of graded tone and color, an important aspect of such illustrations is an accurate initial drawing that provides the basis for the airbrush work. This should be worked out in detail on paper and transferred to the artboard by any suitable method: this example was traced by the conventional method using type detail paper, which is stronger than tracing paper and slightly more opaque. Transfer paper can also be used, but it is important that the line quality put down on the artboard is not too heavy, smudged or gritty, as this will show up in the airbrushed color. The masking sequence is planned according to the individual areas of the image — sky, mountains, sand, fabric, marble column, apple.

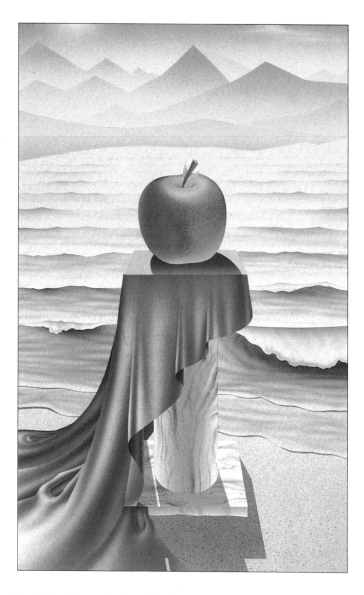

The finished image is strongly defined in terms of color areas, giving the key to the masking sequence. The following pages show how this result is achieved section by section.

To start, make a complete outline drawing of the composition on tracing or type detail paper, following all the elements in the image that have a definite edge. Clean an artboard and lightly trace the lines of the drawing onto the board surface. Apply masking film to the artboard, leaving a margin of film around the edges of the image. Using a sharp X-acto knife, cut the mask along the outlines of each main section of the drawing.

The image can be broken down into separate subjects, each of which is treated individually. First, remove the mask from the sky area, except for the disk representing the sun. Airbrush a graded tone of blue overall **1**. Remove the circle mask and work freehand with white to form the sun's rays and the cloud effect **2**. When dry, re-mask the sky; remove the masks on the mountains in turn and airbrush individual shapes in graded tones of blue and gray **3**.

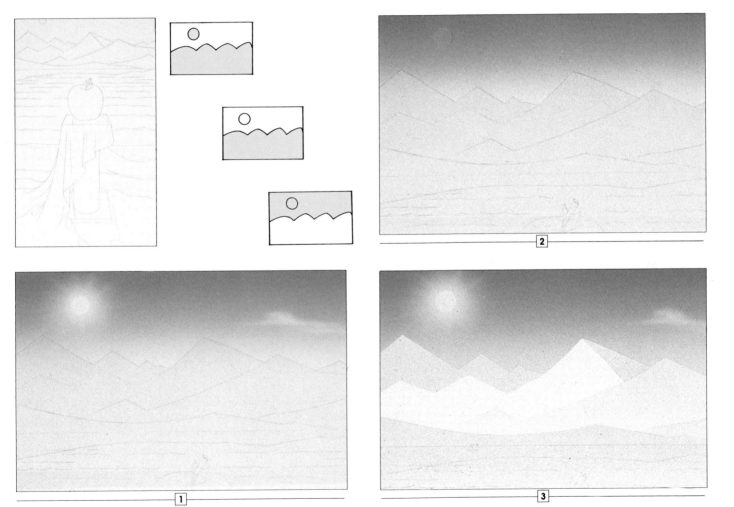

COMBINED GRADATION TECHNIQUES

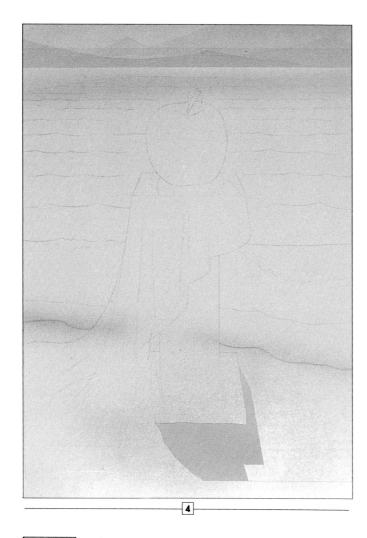

4

5

Lift the mask section on the shadow at the base of the column. Spray with a solid medium tone of gray-brown to establish a tonal key. Remove the mask section at the top of the sand area and spray lightly in the same color. Cut and lift a fine sliver of the masking film along the ripple extending on either side of the column, and spray **4** to create a fluid, hard-edged line. Repeat to form a second rippling line above. Remove the section of mask in

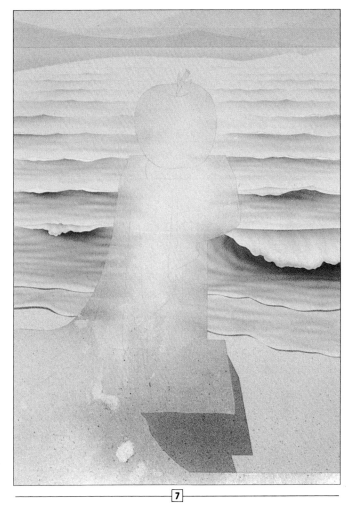

between and work freehand across the unmasked area to develop the wave effect as shown, spraying white over brown to achieve the foaming crests of the waves **5**. Spray each section of the sand in sequence to establish dark and mid-tones. Remask the lower part of the image and go over the sand area with yellow ocher to soften the contrasts, leaving highlighted areas white **6**. Remove foreground masking and spray with graded yellow **7**.

COMBINED GRADATION TECHNIQUES

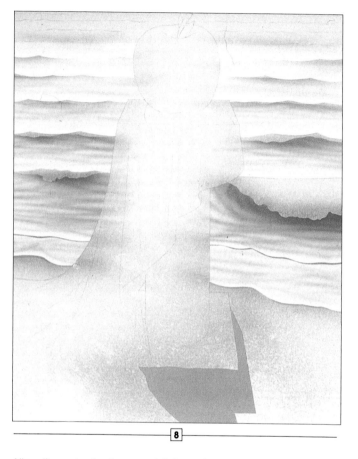

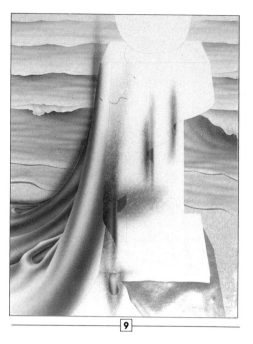

8

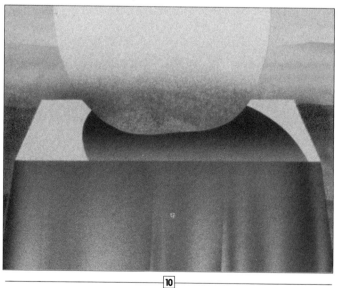

9

10

Allow the color to dry completely and remask the area of sand; remove the masking film from the details of the fabric folds and spray the darkest tones, working back and forth across the shape. Lift the mask on the left-hand sections of the drapery and spray lines of graded tone to emphasize the direction of the folds and establish mid-tones and highlights **8**. Continue in the same way to develop each section of the fabric in turn, working toward the foreground of the image **9**. On the square of fabric at the top of the column, unmask the shadow area cast by the apple and spray a dark purple tone; then remove the sections of mask on either side and spray a very light tone to form a hard-edged contrast **10**.

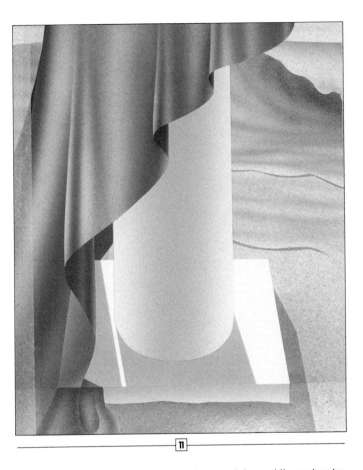

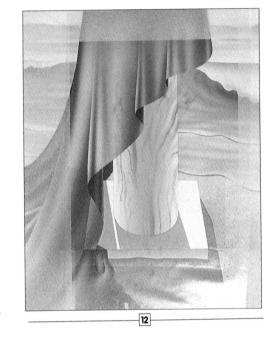

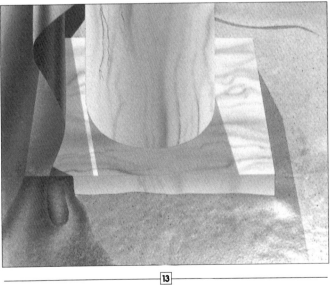

When the rendering of the drapery is complete and the color dry, cover the area again with masking film and expose the shape of the column. Spray a lightly graded tone of gray to make the column appear rounded. Mask and spray the highlights and shadows on the base individually **11**. Remove the masking from the whole area and adjust the balance of tones **12** to enhance the impression of solid shapes and shadows, using flat and graded tones as appropriate. Charge the airbrush with a darker gray and work finely down the column and across the base to create the marble veining **13**. Keep the airbrush nozzle close to the surface to control the width of line.

COMBINED GRADATION TECHNIQUES

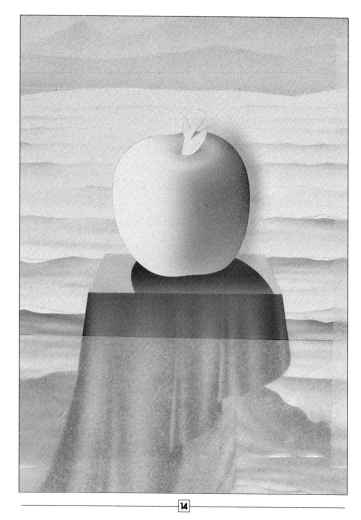

14

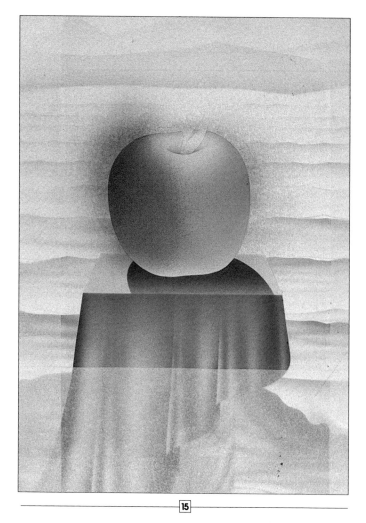

15

Remove the masking film from the apple and replace the masking in all adjacent sections of the image. Keep pieces of film in place over the stalk and leaves of the apple. Airbrush the right-hand side with green **14**, then without further masking, spray the left-hand side with red, merging the colors gently where they meet and leaving a pale highlight area around the top of the apple **15**. Build up the color at the outer edges of the shape.

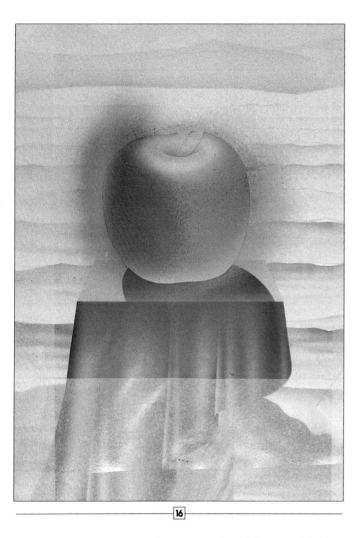

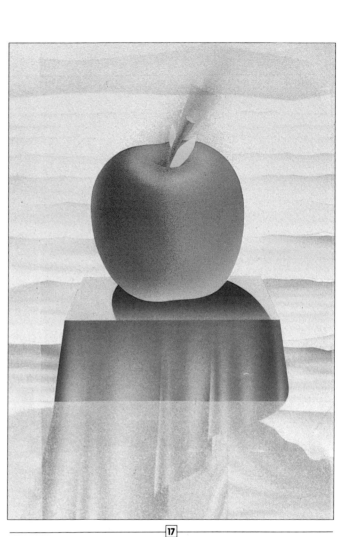

Enhance the rounded effect by overspraying white around the top highlight area, and gently lightening the left-hand and lower edge of the shape in the same way **16**. Mix a darker tone of green and add shadow detail at the base of the apple stalk; slightly darken the right-hand side of the apple. Finally, remove the masks from the leaf shapes and spray with a brighter, yellow-toned green. Mask the stalk carefully and color with a graded tone of brown **17**.

COMBINED GRADATION TECHNIQUES

GLOSSARY

Acetate A transparent film, produced in a variety of weights and thicknesses, used in airbrush work for loose masking and cut stencils.

Acrylics Paints consisting of pigments dispersed in a binding medium of synthetic acrylic resin, available in liquid or paste form.

Artboard A smooth-surfaced support particularly suitable for airbrushing as the surface allows a high degree of finish to graphic work and illustration. It comes in various thicknesses, flexible or rigid.

Artwork A graphic image or illustration of any kind, which may be intended for reproduction.

Bleed 1 A ragged line of color caused by paint penetrating beneath the edge of a mask. **2** The effect of a color which shows through an overlying layer of opaque paint: this occurs naturally with certain strong pigments.

Color cup A type of paint reservoir attached to certain types of airbrush; a metal bowl which is an integral part of the tool.

Compressor An electrically-driven mechanism designed to supply a continuous source of air to an airbrush.

Double-action The mechanism of an airbrush which allows paint and air supplies to be separately manipulated by the airbrush user. In independent double-action airbrushes, paint and air can be fed through in variable proportions, enabling the user to adjust the spray quality.

Film masking See Masking film.

Freehand The technique of airbrushing without use of masks.

Ghosting The method of overlaying layers of spray to render a surface as if it were transparent.

Gouache A type of paint consisting of pigment in a gum binder and including a filler that makes the color opaque. It is a viscous substance and must be diluted with water to a fluid consistency for use in airbrushing.

Grain The surface quality of paper or board resulting from the texture of its constituent fibers and the degree of surface finish.

Ground 1 The surface of the support used for airbrush painting, e.g. paper or board. **2** The overall area of a picture or design on which particular images or graphic elements are arranged.

Hard edge The boundary of a shape or area of color in an airbrush image which forms a clean edge between that and the adjacent section of the image. In airbrushing, this effect is produced by hard masking.

Hard masking The use of masks such as masking film or stiff cardboard which lie flush with the support and create sharp outlines to the masked shapes.

Highlights The lightest areas of an image. With transparent media, highlights may be formed by leaving areas unsprayed to show the white of the support; using opaque color, highlights can be sprayed in white to enhance tonal contrast or create special effects.

Illustration An image accompanying a specific text or depicting a given idea or action; often intended for reproduction in printed works.

Ink A liquid medium for drawing and painting, available in black, white and a range of colors; ink is categorized as a transparent medium.

Internal atomization The process by which the medium and air supply are brought together within the nozzle of an airbrush to produce the fine atomized spray of color.

Keyline An outline drawing establishing the area of an image and the structure of its component parts.

Knock back To reduce highlights or other light areas of an image, subduing the overall tonal contrast, by spraying over white areas and pale tones.

Loose masking The use as masks of materials such as paper, cardboard, plastic templates, etc., which do not adhere to the surface of the support and

can be lifted or repositioned according to the effect required. 3-D objects can also be used for particular effects of shape and texture.

Mask Any material or object placed in the path of the airbrush spray to prevent the spray from falling on the surface of the support. *See* Hard masking, Loose masking, Masking film, Soft masking.

Masking film A flexible, self-adhesive transparent plastic film laid over a support to act as a mask. The material adheres to the surface of the support, but the quality of the adhesive allows it to be lifted cleanly without damage to the underlying surface. This is the most precise masking material for airbrush work.

Medium The substance used for creating or coloring an image, e.g. paint or ink. *See* Acrylics, Gouache, Ink, Watercolor.

Modeling The method of using tone and color to render a two-dimensional image with an impression of three-dimensional solidity.

Needle A component of the airbrush which has the function of carrying the medium from the paint reservoir to the nozzle of the airbrush.

Opaque medium A paint capable of concealing surface marks, such as lines of a drawing or previous layers of paint. This is due to a filler in the paint which makes it tend to dry to a flat, even finish of solid color. *See* Gouache.

Propellant The mechanism used to supply air to an airbrush. Cans of compressed air are available which can be attached to the airbrush by a valve and airhose, but a compressor is the most efficient means of continuous supply.

Pulsing An action produced by certain types of compressor that cannot store air and may provide a slightly uneven air supply which affects the quality of the airbrush spray.

Rendering The process of developing a composition from a simple drawing to a highly finished, often illusionistic image.

Reservoir The part of an airbrush which contains the supply of medium to be converted into spray form. In some airbrushes this is a recess in the body of the airbrush, in others it is a color cup mounted on the airbrush or a jar attached above or below the paint channel.

Scratching back The process of scraping paint from a support with an X-acto knife or other fine blade to create a highlight area or remove color when an error has been made.

Soft edge The effect of using loose masks or freehand airbrushing to create indefinite outlines and soften the transition between one area of an image and the next.

Soft masking The use of masks held at a distance from the support surface to soften the sprayed area; or a masking material which creates an amorphous effect, such as a cotton ball.

Spatter A mottled color effect of uneven spray particles produced by using a specially made spatter cap attachment for the airbrush nozzle, or by using the control button to vary the paint/air ratio within the airbrush.

Spatter cap A nozzle attachment for an airbrush designed to produce an uneven spray effect.

Tone 1 The scale of relative values from light to dark, visually demonstrated in terms of the range from black, through gray, to white, but also applicable to certain color effects. **2** Any given value of lightness or darkness within a picture or design, or in an individual component of an image.

Transparent medium A medium such as watercolor or ink which gains color intensity in successive applications but does not conceal underlying marks on the surface of the support.

Vignette 1 A graded tone. **2** An area of graded tone used to frame or focus a central image.

Watercolor A water-soluble paint consisting of finely ground pigment evenly dispersed in a gum binder. It is available in solid and liquid forms; liquid watercolor is the most useful type for airbrushing.

INDEX

CREDITS

p14 Pete Kelly, courtesy of
Meiklejohn Illustration;
p15 Barry Lepard, courtesy of
Meiklejohn Illustration;
p27 John Charles; **p28** Pete
Kelly, courtesy of Meiklejohn
Illustration; **p29** Trevor Webb,
courtesy of Meiklejohn
Illustration; **p41** Brett Breckon and
Stills Design Group; **p45** Brian
McIntyre, courtesy of Ian
Fleming and Associates

Demonstrations by Mark Taylor
Diagrams by Craig Austen,
Mick Hill and Don Jackson